MW00682671

To: _____

From: _____

My Heart Belongs to Mom

Appreciating Mom
in Pictures and Words

A Picture Book
for Grown-Ups

J.S. Salt

Published by
Shake It! Books, LLC
P.O. Box 6565
Thousand Oaks, CA 91359
Toll Free (877) Shake It
www.*shake*that*brain*.com

Cover Photograph: © Ewing Galloway/Index Stock Imagery, Inc.

This book is available at special discounts for bulk purchase for sales promotions,
premiums, fund-raising and educational use. Special books, or book excerpts,
can also be created to fit specific needs. Got a need? We'll try to fill it.

Printed in Canada
ISBN: 1-931657-05-X
10 9 8 7 6 5 4 3 2 1

*To my Mom**

*See page 85.

*H*ere's to Mom, a hero to me.

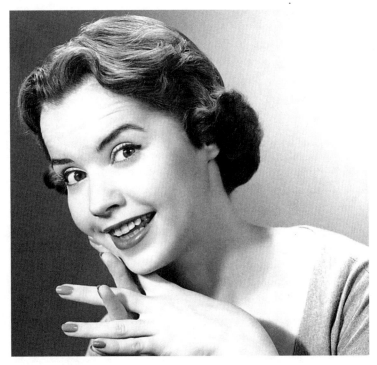

"Well, gee… I'm just doing my job!"

A woman who's tender…

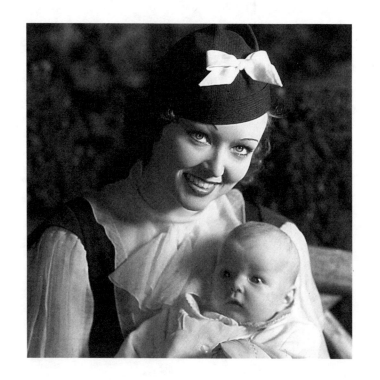

And a woman who's strong…

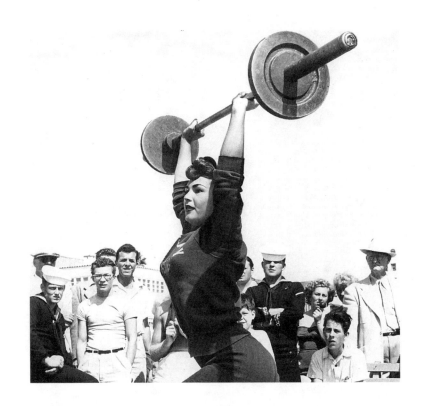

You get the job done all day long.

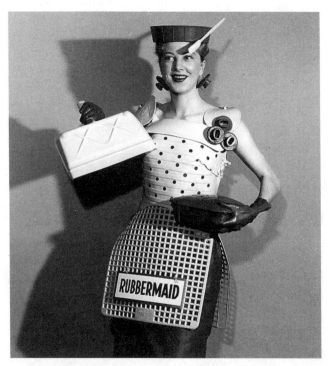

"Cooking? Cleaning? Kitchen couture?"

So how do you work without taking a rest
and always wind up looking your best?

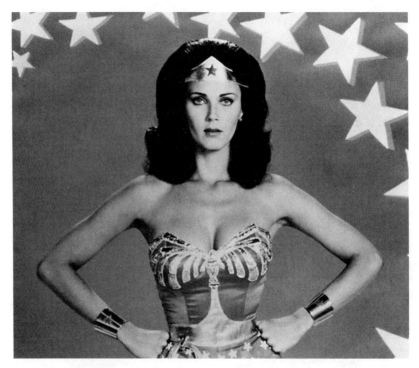

"Didn't you know? I'm Wonder Woman!"

*H*ere's to Mom, for all you do.
From making sure there's enough to eat…

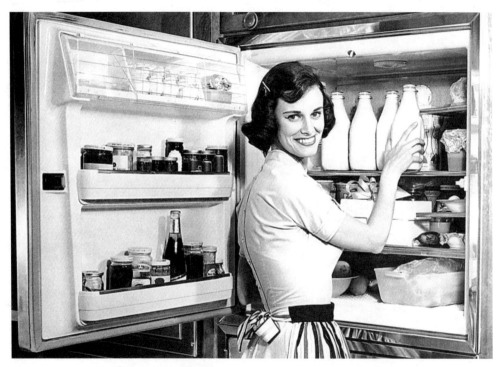

"And if you need more milk, I've got a cow out back."

To making sure your message gets through.

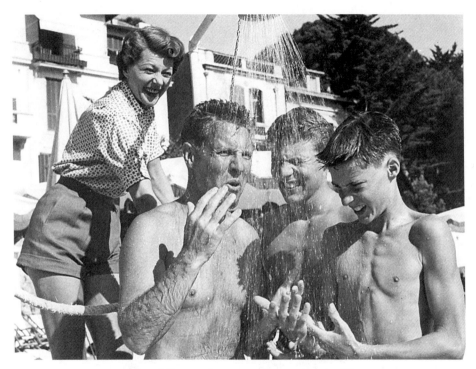

"I told you it was shower time!"

No matter the challenge, you give it your all.

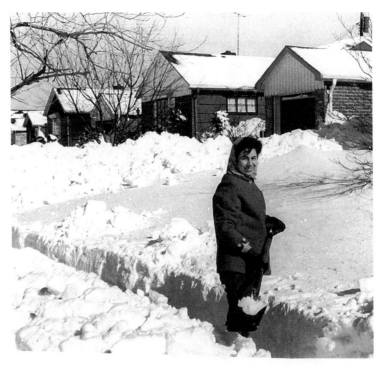

"Just three more houses and I've finished the block!"

From joining in when duty calls…

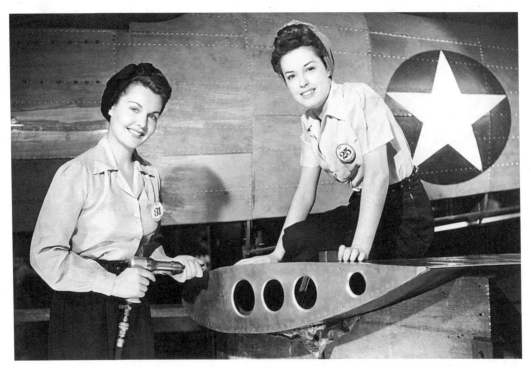

"Build an airplane? I'll be done before lunch!"

To proudly working through it all.

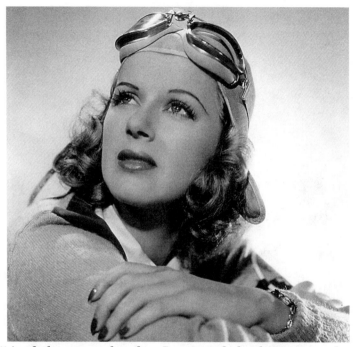

"And that was the day I painted the house, made dinner for eight, and flew my first combat mission."

You greet every day so happy and bright,
showing the way to meet any strife.

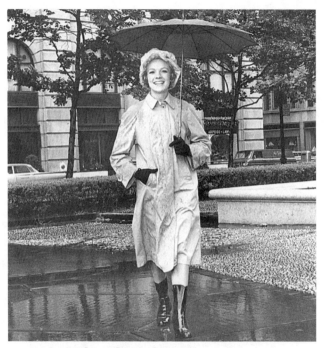

"Blue skies shining on me...
Nothing but blue skies do I see!"

You cheer me on when I want to quit…

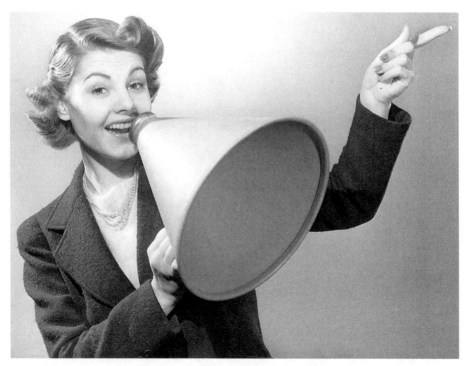

"You can do it, yes you can!"

And guide me on with those handy tips.

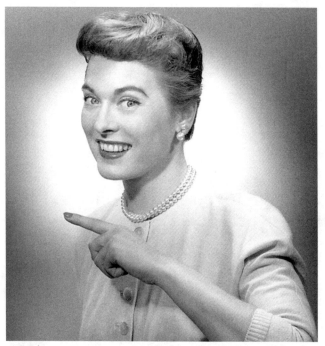

"Your room is over there. And if you don't pick it up… you're not leaving your room."

And even though you know I only tell the truth…

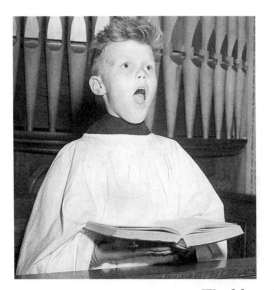 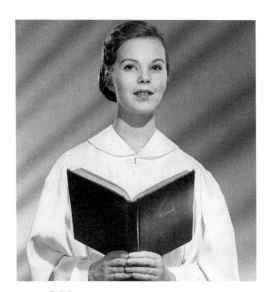

Would we lie to you???

Thanks for those times you help
shake it loose, asking so dearly...

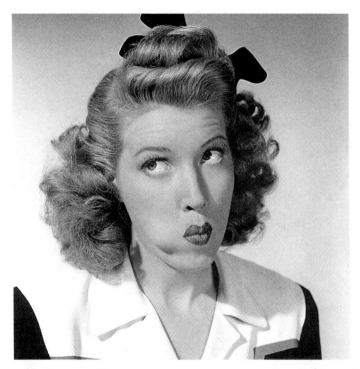

…Is that really a story you expect me to believe?

*H*ere's to Mom! You lead the way.
From showing me how to enjoy getting wet...

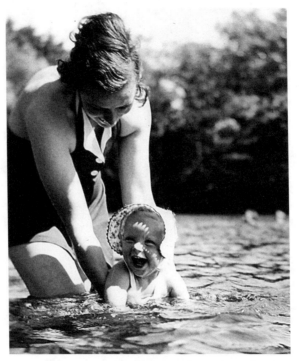

"I'm swimming, I'm swimming!"

To guiding me through those first baby steps.

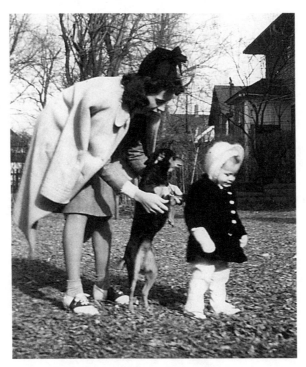

"C'mon, Spot. Follow me!"

From taking care of all those feedings…

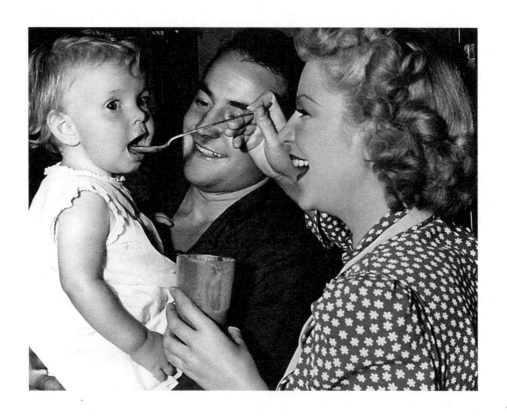

To making time for all those meetings.

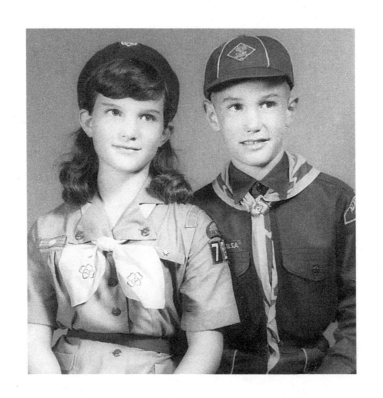

43

Thanks for teaching me to share,
and to always be prepared.

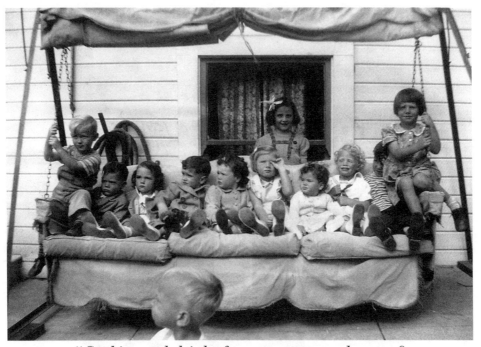

"Cookies and drinks for our unexpected guests?
I'll be right back with a complete selection!"

\mathcal{H}ere's to Mom, a woman who knows
something about most anything at all.
From always keeping your eye on the ball...

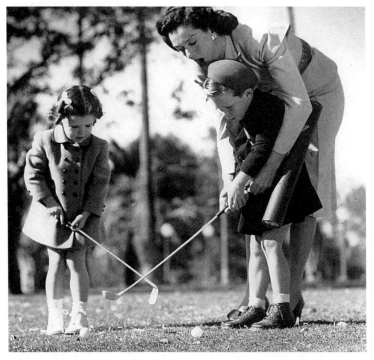

"Okay. First decide *which ball* you want to hit."

To hanging tough through it all.

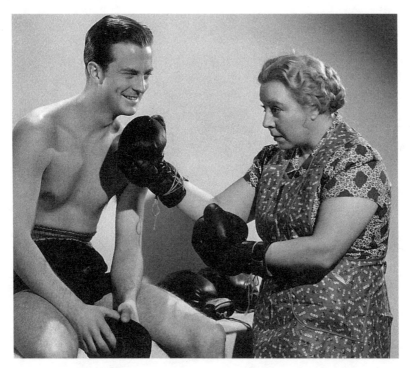

"Laugh if you want. I've *still* got my stuff!"

So if sometimes you're out of step...

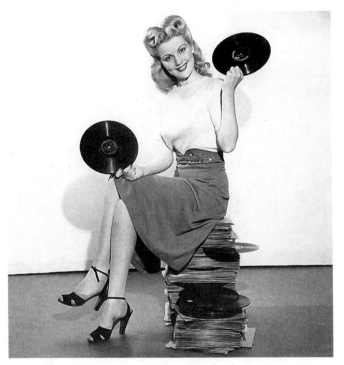

"I sure do dig these swell new platters!"

Or just don't know the rules…

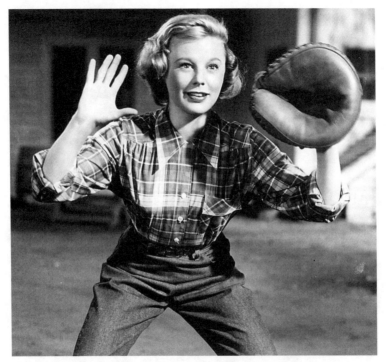

"C'mon, team. Let's make a touchdown!"

Count on me to understand.
After all, you're called upon to juggle an awful lot.
You keep all those balls in the air...

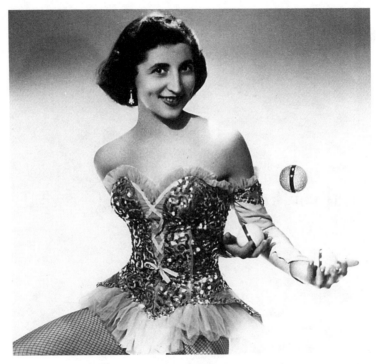

"Just another day for Mom!"

And you keep a smile no matter what.

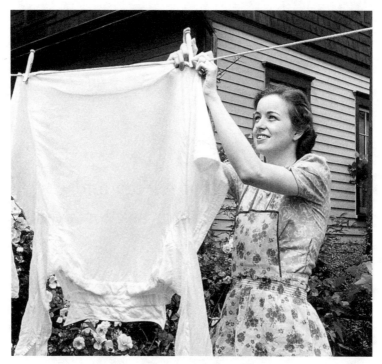

"Sure I'm happy. I'm keeping America clean!"

A woman so full of energy and zest,
you never complain or ask for a rest.

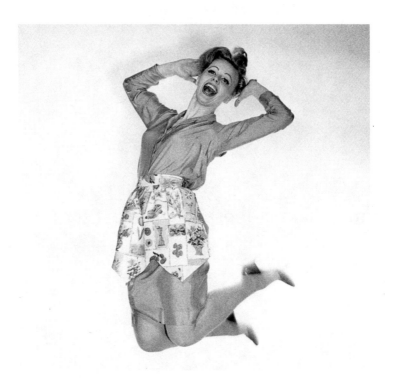

"I'm free, I'm free! The kitchen's all done!"

From making those snacks just for me...

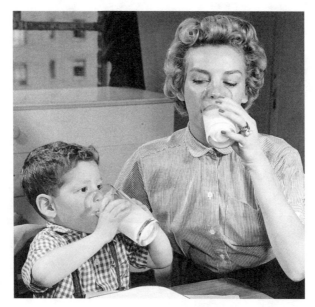

"Here's lookin' at you, Mom!"

To keeping each day wrinkle-free.

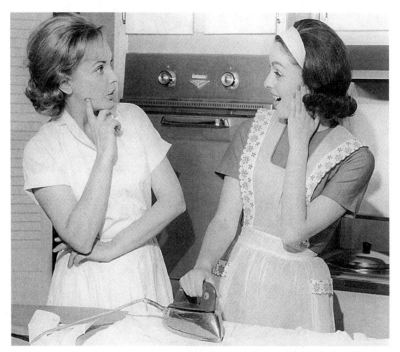

"You still have time for ironing?" "Didn't you know? That's what the middle of the night is for!"

You make all those calls to arrange my life…

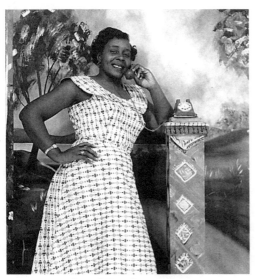

"So if I take Adam
skating on Monday..."

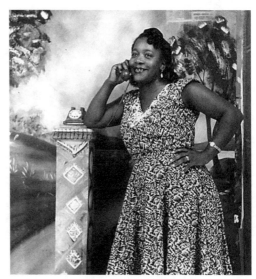

"...I'll pick up Nancy
from soccer on Tuesday!"

And log all those miles from morning till night.

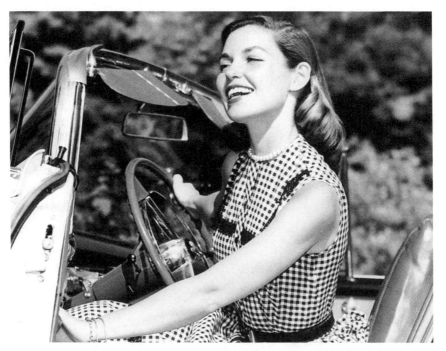

"C'mon, everyone! I still need to drive my 300 miles today!"

It's a delicate act you balance so well,
right from the start of that wake-up bell.

"Okay, here I go! Get the kids dressed, take them to school, get myself to work and back, pick up the kids, get them to soccer, make dinner, clean up, help them with their homework,

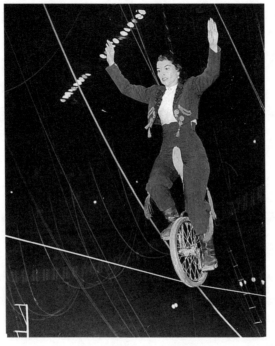

get them bathed and tuck them in, answer my e-mails, pay all the bills, make a cake for the bake sale, finish that report for the biggest client I've ever landed, and not trip up or miss a step?"

Compared to all that… riding a tightrope looks easy to me!

So when business keeps you working late
or traveling out of town...

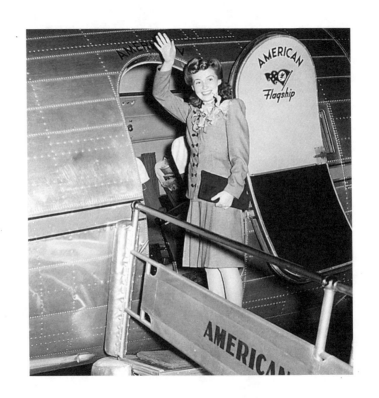

Thanks so much for calling to say…

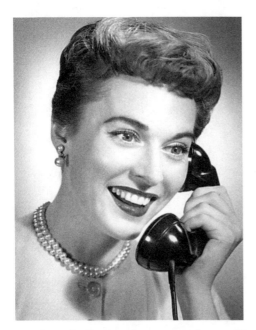

"…I wish I were home with you!"

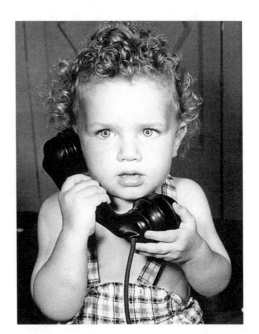

"That's okay, I understand."

Then Mom comes home and it's a bright new day...

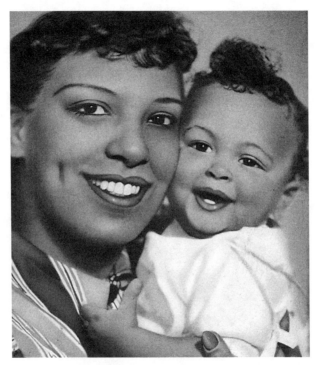

...'Cause a hug from you sends the blues away!

*H*ere's to Mom for being so clever,
stretching those dollars better than ever.

"Don't you worry, I'll find a way
to pay for *anything* you need!"

So thanks for the shopping
and thanks for the shoes...

"See, kids? Shopping is fun! And it's
something you can enjoy all your life!"

And thanks for those tips
on what clothing to choose.

"We're lookin' good, alright—thanks to
Mom and her smart eye for fashion!"

Thanks, as well, for that boundless cheer
you manage to spread all through the year.

"Who needs Disneyland when we've got Lemonland!"

From having a party each time we eat…

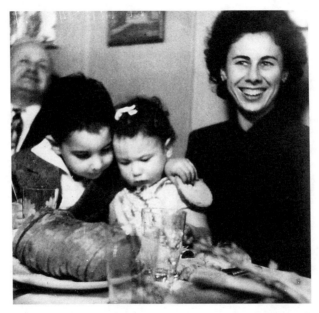

"Don't worry. We're just *starting* with bread."

To trying your best to get me to sleep.

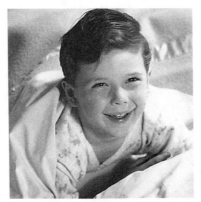

"One more story,
two more songs
and
five more hugs
before you go?"

From leading the way each Fourth of July…

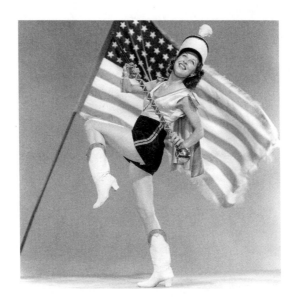

To leaving those presents for each gal and guy.

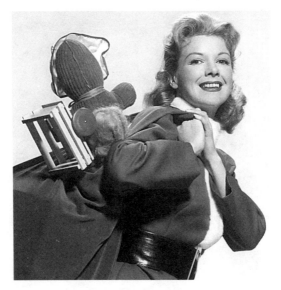

"Anyone here been naughty this year?"

No matter what gifts you bring anew,
not a one compares to you!

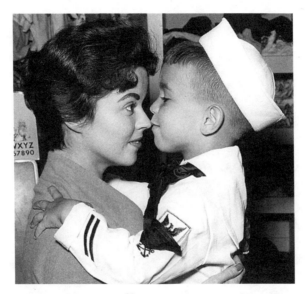

"Mom, will you marry me?"

From times we're out with everyone…

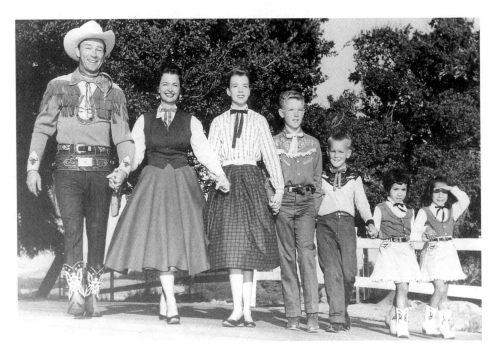

"We are fam-i-ly... All my cowpokes and me!"

To times it's just one-on-one...

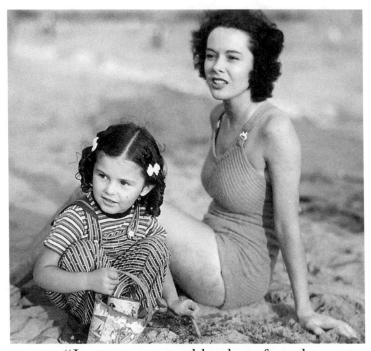

"Just you, me, and bucket of sand.
Life sure is grand!"

I sure do love being there with you...

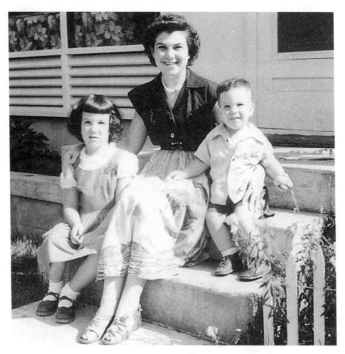

...Even if nothing is what we do.

So thanks for the caring…

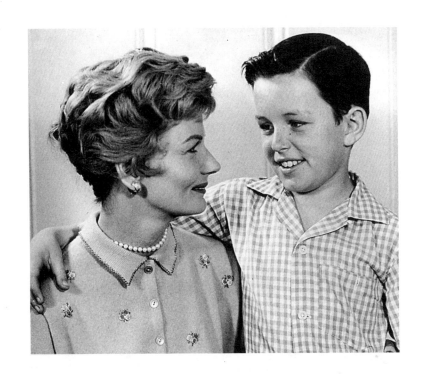

Thanks for the fun…

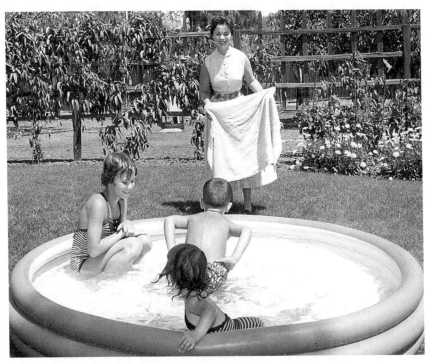

"Last one out has wrinkled fingers!"

And thanks for the lift when I needed one.

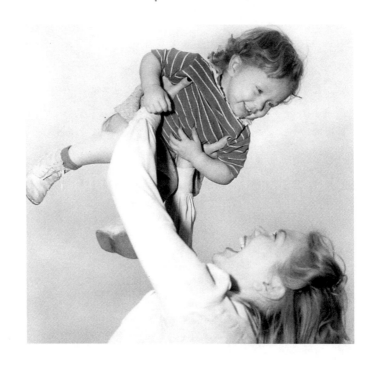

Thanks, as well, for those yummy cakes…

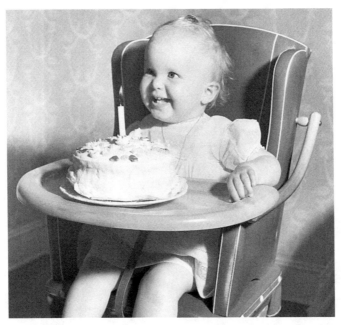

"I can't believe it—you remembered my birthday!"

And all the fuss you love to make.

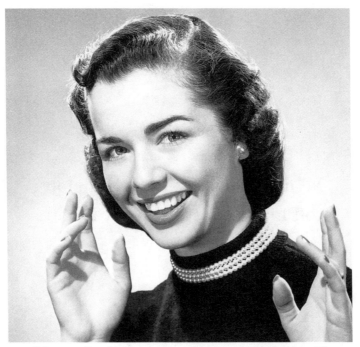

"A candy dish in the shape of your hand?
It's just what I've always wanted!"

No matter what life has in store,
you make sure it's never a bore.

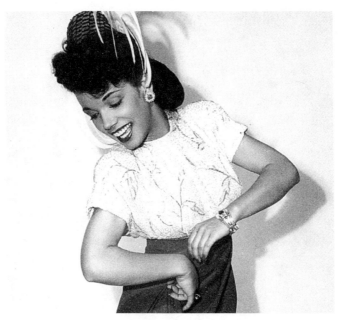

"C'mon, everyone. It's flamenco time!"

And when I fall down or scrape my shin...

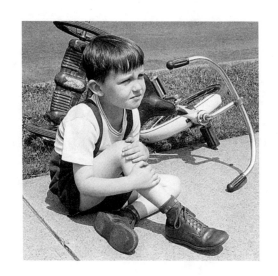

You're the best nurse that's ever been!

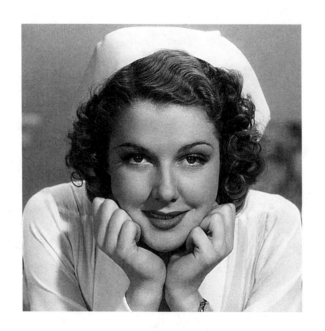

So thanks for those eyes shining love-light on me…

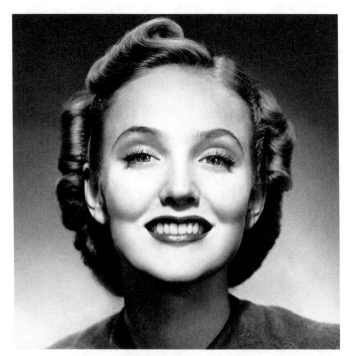

"That's my child and I'm in love!"

And thanks for the pride you allow me to see.

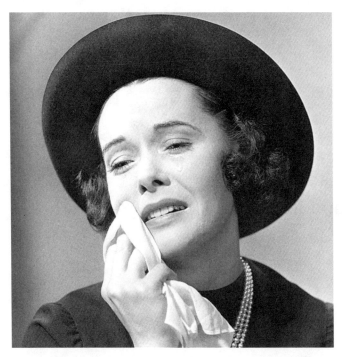

"My child. A kindergarten graduate!"

Thanks for getting me packed and off to school,
and for imparting all those good rules.

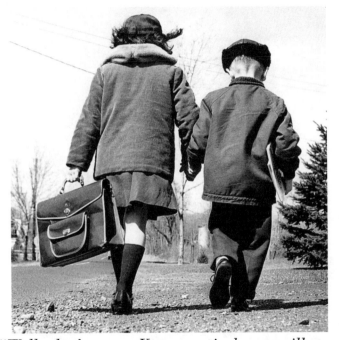

"*Walk, don't run... Keep your jackets on till you get inside... And don't forget I love you so!*"

Thanks for the teaching,
thanks for believing…

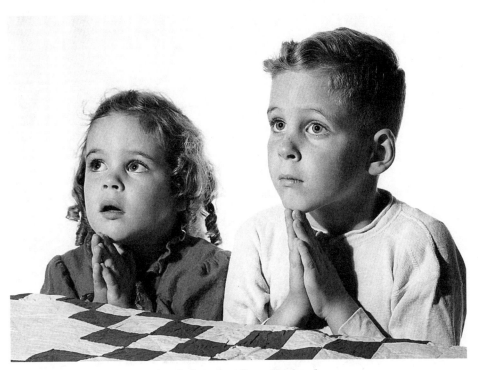

...And thanks for all the love.

For all you do and all you are,
thanks for being Mom!

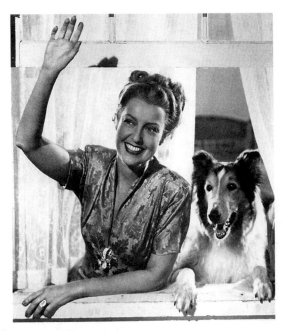

And thanks to you... for being you!

More "Picture Books for Grown-Ups"

My Heart Belongs to Dad

Boys Will Be Boys

Girls Will Be Girls

Fairy Tales Can Come True

Also By J.S. Salt

How To Be The Almost Perfect Husband:
By Wives Who Know

How To Be The Almost Perfect Wife:
By Husbands Who Know

What The World Needs Now:
Kids' Advice on Treating People Right